Diary of a Santa Fe Cat

D1191825

PEGGY VAN HULSTEYN
Illustrated by JACQUELYN QUINTANA

SHERMAN ASHER Publishing

Illustrations by Jacquelyn Quintana
Cover Design by Janice St. Marie
Book Design by Judith Rafaela

First Edition
Printed in the United States of America
ISBN 1-890932-10-8

Library of Congress Cataloging-in-Publication Data

Van Hulsteyn, Peggy.
 Diary of a Santa Fe cat / Peggy van Hulsteyn : Illustrated by
Jacquelyn Quintana. — 1st ed.
 p. cm.
 ISBN 1-890932-10-8 (alk. paper)
 1. Santa Fe (N.M.)—Social life and customs—Humor. 2. Santa
Fe (N.M.)—Description and travel—Humor. 3. Cats—Humor.
I. Quintana, Jacquelyn. II. Title.
F804.S25V36 1998 99-11201
978.9'56—dc21 CIP

Sherman Asher Publishing, PO Box 2853, Santa Fe, NM 87504
Changing the World One Book at a Time ™

Dedication

To Vanity who showed me how magical cats can be

Acknowledgments

To David, who introduced me to the beguiling world of cats. To Bosque and Apache, my Russian blues who keep me feeling in the pink. To Judith Sherman Asher and Nancy Fay for making this a delightful experience.

To Jacquelyn Quintana for her wonderful illustrations.

Thanks to John Sherman, Janet Ford, Valerie Brooker, Susan Hazen-Hammond, Miriam Sagan, Jean Schaumberg, Lynn Cline, and Elaine Coleman for their catty remarks.

Also to Jeanie Fleming, Susan Arritt, Sarah Lovett, Reina Attias, Seale Ballenger, Don and Alice Liska, Kelly Pergande, Ruth Holmes, P.J. Liebson, Carolyn Stupin, Jann Wolcott, Leda Silver, and Coco Pinkerton.

Contents

Abandoned

It was the type of late summer day for which Santa Fe is famous. The sky was turquoise blue, the air was crisp, the scent of chiles being roasted filled the air, the adobes were sparkling in the brilliant sunlight, and I could have cared less. You see, I was stuck in the back seat of a car going to someplace unknown. Car trips, as you well know, seldom mean anything positive to cats.

Automobiles, in the mind of a one-year-old cat like me, are some sort of medieval torture chamber to remind us felines that humans always want to have the upper hand. Cars roll and bounce, giving the horrible sensation of being on a roller coaster out of control. At best they are miserable, at worst, catastrophic.

To make matters worse, on this particular sparkling summer day, my owners seemed to have been out in the garden too long without their sun bonnets. Whereas they had been formerly kind, considerate, and rational beings, they were now talking absolute gibberish.

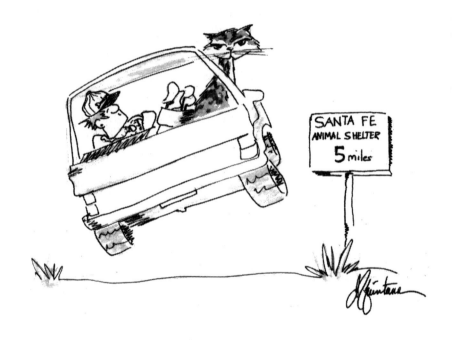

"There, there, dear," I was told by the Jezebel who once stroked my fur, "you mustn't scratch. We're taking you to a lovely place."

"Lovely place," I meowed more piteously than inquisitively. "Could you be more specific? You mean like Cats R Us Toy Store or the Audubon Small Bird Petting Zoo?"

"Since you're a spiritual being, I know you'll understand our predicament," she continued. "Whitefeather Mooncloud, our Tarot card reader, told us in no uncertain terms that we no longer need to take care of a creature. She says that the cards do not lie, and it is time for us to take care of ourselves.'"

"We gotta follow our destiny," chimed in the male partner in this act of treachery and betrayal. He fiddled with the new turquoise earring in his left ear and fingered his crystal necklace. "De channeler confirmed it," my once-kind master added in his thick Brooklyn accent. "We got in touch with our past lives and what do you know —we were de prize parakeets of Cleopatra. What a life we musta had —waited on claw and beak, paraded around at dem special ceremonies, dat is until one day we becomes history when Sphinx, Cleo's cat gobbles us up for a mid-afternoon snack. Dat's why we don't want you no longer."

"Yeah," added my erstwhile beloved mistress, "so now we're getting in touch with our anger towards cats. You can see why we must set you free."

I turned away, in hurt resentment. It got worse.

"I'm gettin' in touch with my Inner Child," said the fifty-eight-year-old male. The little fellow was obviously having some sort of tantrum as he pronounced in no uncertain terms: "I gotta be free. I'm too young for responsibilities. Dat's it for kitty litter."

Just then, my inner kitten spoke to me and commanded me to take a pee in the master's golf shoes which, as luck would have it, were conveniently sitting on the back seat. My turncoat owner wasn't paying attention, so he should have a nice surprise waiting for him when he set out for his spiritual eighteen holes at Las Campanas.

"You got nine lives," they kept repeating. "You'll be on your own spiritual voyage. They'll take good care of you here and find you a delightful home."

Then the car pulled to a sickening halt in front of what I clearly recognized as the Animal Shelter. My heart dropped down to my quivering white paws. How could they do this to me? Hadn't I given them the best nine months of my life?

As my female owner tried to stuff me into a carrying case, I managed to give her a killer scratch on the arm, just to let it be known what I thought of this little surprise.

Rescued

The next thing I knew, these no-good-nicks, who had formerly pretended to be my friends, deposited me at the counter, and beat a hasty retreat. I was unceremoniously placed in some crummy little cage that contained a water dish and a box of litter. I was surrounded by many fellow creatures in similar straits.

"What are you in for?" queried a sleek-looking Persian. "In my case, the owners redecorated and they decided I didn't match the new couch."

"I clawed some crappy piece of furniture that my guys thought was valuable," boasted a jet-black kitten. "The scratch marks improved the looks of it, if you ask me."

I wasn't in the mood to be social just yet. I had to sniff out the situation, as it were, to see just how much energy it was going to take to get out of this joint alive.

As it turned out a large percentage of these inmates could have held their heads up high at any cat show. There were

also a number of average-looking tabbies and a few handi-capped fellows—one cat who was blind, another who had lost a limb. The first time I got stuck at an animal shelter, when I was a three-month-old kitten, I thought for sure that these guys were goners. I found out, though, that you can't dismiss the do-gooders who come to shelters. Sometimes they are pushovers for the catatonic and pass up beautiful babes like me.

I must confess that I wasn't too worried. Any moron could quickly tell that I was fur and shoulders better looking than any other feline in the room. Perhaps modesty is not one of my many virtues, which may be the reason why I chose to name myself Vanity. But I have to tell you, all kidding aside, I am drop-dead gorgeous. I am a Calico, which everyone knows, is the most beautiful type of cat around. My elegant, shiny fur is a marvelous blend of black, tan, and white. I have the most adorable whiskers and my perfectly formed feet are complete with built-in white socks. My purr is bell-like and my manners are impeccable. In short, I am the poster cat for elegance.

I don't know how long I was in that place, but it seemed like forever. Several times, while I was napping, a cat would disappear from a cage on either side of me. I managed to convince myself that the midnight-black kitty with a southern

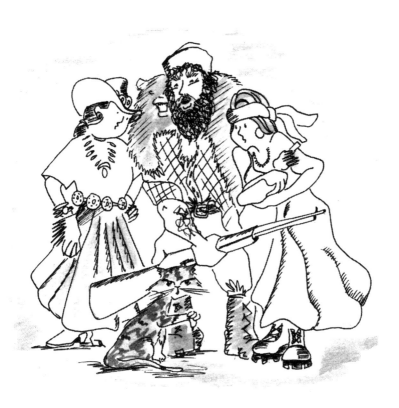

accent and the big yellow tom who had been around the block a time or two had been adopted by a *Father Knows Best* type of family. But in my innermost being, the place where my fur balls originate, I had a queasy feeling about what goes on in the back rooms of animal shelters. I didn't just fall off the turnip truck, you know.

I knew full well that I had better put on the performance of a lifetime. Mythology may give us nine lives; I just wanted to postpone the end of this one.

To prepare myself for the parade of humans about to display their wares, I groomed myself. Licking is an art form of which I'm the master. I also practiced turning on my back in order to look particularly fetching and worked on a meow that was simultaneously endearing and pathetic.

The human circus commenced just after morning feeding time. I surveyed each subject carefully, saving my act for just the right time. First there was The Great Earth Mother, with three kids in tow and one suckling her breast. This species is prevalent in Santa Fe and I must admit they are not my style. Call me snobbish, call me elitist, but I like a well-dressed woman and this woman was anything but. She was decked out in a calico long swaying skirt with combat boots barely visible

underneath it. A see-through blouse, a bandana with a feather stuck in it, and the suckling child completed the ensemble. These kids would all be tail pullers and discipline in this household would be at a minimum. Worst of all, I could tell this Earth Mother would fill my dinner bowl with tasteless, organic cat food. No thanks!

Next in line was another Santa Fe type, the "Look Everybody, I Live in Santa Fe Now" breed. She was dripping in squash blossoms, fetishes, and concho belts, and had four rings on every finger. She had a kachina doll picture embroidered on her blue jean jacket and wore Santa Fe–designed cowboy boots. I heard her tell one of the shelter's staff that she had arrived in town last week from Oklahoma. Worst of all, she was carrying an overly precious matching outfit for her cat. That poor animal was not going to be me!

When I sensed that a scruffy six-foot-tall man who resembled an unmade bed was eyeing me, I knew that the situation had become cataclysmic; I had better adopt a family fast! A shudder went up and down my spine when this Grizzly Adams look-alike announced to anyone within earshot that: "I'm looking for two good outdoor mousers. Coyote got the last two. Great Horned Owl stole the one 'afore that. Which one of

you critters is a survivor?" His sardonic laugh made me curl up by the side of my cage and try to look invisible.

It was from this vulnerable position that I spotted the couple that I knew right off were the pet humans I wanted to adopt. The man was in his mid-fifties and seemed gentle enough to suit my fancy. He had brown curly hair and an impish grin. He had a solid air about him and it didn't look like he would be returning me in a year's time to this dreaded place. Best of all, he was a punster and there's nothing more appealing on a cold winter night than lying around by the fire exchanging quips with the master. Now I'll grant you that the pun I was subjected to was corny, but this guy had potential. He had written on a giant poster board," We've got a glorious home for a champion *Mauser*. If any of you *katz* can read my sign, it will be a sign that you're the cat for me." Of course I meowed enthusiastically as soon as I read his hackneyed prose. I even purred a little laugh so he could tell that I was a fellow punster. I don't know a lot of German (French is more my specialty), but I do know the difference between a gun and a rodent remover. It was a beginning; I could work with him.

The 40-something woman who accompanied him seemed a little neurotic but had kindly eyes. She was beautifully decked out in a multicolored pantsuit from the window of

Ann Taylor. She had a sense of style that suggested class. Clearly, the animal shelter was not her natural milieu, but I could sense that she was sympathetic to our plight. I had the feeling she might have been —dare I say it—a dog person and therefore wasn't totally comfortable with my species. She was, however, sensitive and was therefore made to order for my skills. I'd have her eating out of my hand (or better yet have me eating cat food out of hers) before you could say CATECHISM. She inquired plaintively, "If I took you home, would you catch a mouse?"

I meowed in the affirmative. Besides all their other attributes, they were promising that there would be mice for me to bat around. This couple was clearly the catalyst that I needed to get me out of this dump. I pulled out all the stops. I looked desperate; I looked adorable. I meowed sweetly; I meowed pathetically; I meowed playfully. I gave them my most winning "Please take me home" look, right before licking their out-stretched hands.

The next thing I knew some attendant had placed a collar around my neck. Miraculously, in this brief encounter I found a new home and its two owners were mine, hopefully for life (with or without the other eight encores).

In the New Adobe Abode

Today has been so good that I'm afraid I may be dreaming. After leaving the animal shelter we drove to an upscale neighborhood that's so close to town that the owls and the coyotes shouldn't be around to sniff me out for supper. The place we pulled up to is a really elegant-looking home. My new couple, who I haven't named yet, took me inside so that I could get out of that miserable carrying cage. As is required of us cats, I immediately headed for the nearest bedroom and dived underneath the bed. I know that humans think this is because we're scared and insecure, but actually I just wanted to check out the cleanliness of the new place. I gave it the white paw test and it did okay. This also gave me a chance to start my diary; a summary of the day's events will give you some idea of how great my new life is.

Sun hits windowsill—My pet humans lured me out from under the bed with a dish of tuna tacos. Not bad, I have to admit. Are my instincts good or what? The anxious new owners gathered around me, watching my every move. I would prefer a

little privacy with my *petit dejeuner*, but they probably mean well. I guess it will take a little time to train them properly. Right now, though, I would rather eat than train.

Sun pours over sill to middle of the rug—The cat-and-mouse game is officially afoot! This runt of a rodent is no match for me. A few quick bats while standing on his tail quickly dispatch him to the big mouse hole in the sky. My new owners were thrilled by my artistry. So pleased were they that I got another helping of breakfast and a toy filled with catnip; I'm so inundated with praise that, if I weren't a cat, I might be embarrassed.

Sun hits striped bedspread—I've had my fill of physical exercise for one morning, so I spend the next hour or so gazing intently but vacuously at the mountains.

My stomach is growling— it must be time for lunch. I meow to see if I can guilt-monger my new humans into giving me more food. They are pushovers. The woman says to the guy, "Oh the poor darling. Who knows what she's been through. She's probably starving." The male seems to concur with her analysis because he fills my new dish bowl with brown crunchy nuggets. I waste no time in sampling my repast, which is delicious. When I finish I stroll away, looking rather bored, while

the woman says to her husband, "Ah, the little sweetheart was hungry."

The sun is in the skylight, God's in his heaven, and all is right with the world. There's a cushioned *banco*, bathed in sunlight. Ah! The perfect spot for my afternoon sun bath. The house is solar, which is pussycat paradise. Santa Fe homes are made-to-order for cats because the sun shines 317 days a year. Eat your hearts out, Seattle felines!

I follow the sun to a divinely warm, cozy garden room for my afternoon siesta. I must say, Santa Fe is the ideal location for us cats, what with its *mañana* work ethic and all. Most local folks just hang out all day, doing not much. They must be a pretty evolved set of creatures. Not as evolved as us cats, of course, but at least they're moving in the right direction.

Nature calls—Time to use my one-of-a-kind litter box, which is decorated in a Georgia O'Keeffe motif. Pictures of white skulls and vivid flowers are so inspiring. Not only is my litter box swanky, someone (I'll bet the female human) has thoughtfully left me perfect bathroom reading material—the latest issues of my favorite magazines, *Vanity Fur*, *Meowabella*, *Catapolitan*, and *Good Mousekeeping*.

Cocktail hour—My pets fix themselves Margaritas and thoughtfully hand me some milk beautifully presented in a Martini glass. They ask me to join them outside on the veranda for some civilized conversation. As if this weren't enough to make me purr, my thoughtful caretakers present me with my own personalized Crystal Healer Meditation Chamber. I stare into space for what seems like hours while sitting in this thing; onlookers must think I'm channeling dead ancestors. Actually, I'm musing about my former owners' peculiar behavior. I would ordinarily start to pout, but one quick look around this cushy place makes me realize that the Tarot card lady did me a favor—not that this was her intention. My new pet humans check on me periodically, so I manage to combine a pose imperious with a demeanor nobly bland. They eat it up. Just by doing what comes naturally, we cats are considered the spiritual gurus of Santa Fe.

My stomach is rumbling again—but what's this? Before I have to put on any routine, dinner is served! Tonight, for my dining enjoyment, I get salmon enchiladas with chanterelles and sorrel sauce. Scrumptious!

A gorgeous Santa Fe sunset—Wow! Talk about feeling at home. No more pretending to feel skittish. It's time for a long winter's nap. Who cares if it's August?

It's dark out and I'm starting to wake up and feel frisky—I'm feeling so refreshed that it's now time for some cavorting around the several sculptures in the living room. The humans shriek something that sounds like "Hey, that's our new Allan Houser." I can't understand the reason for the excitement, but they do seem to be cheering me on. Fun to watch them wave their hands while running around, pretending to try to catch me. This spirit of fun makes me run even faster.

The moon is out and I feel a song coming on—Now it's time to see what good sports these human critters really are by testing out my Santa Fe coyote stance. I sing to the moon nonstop, but there's not a peep out of them. Did they lose their hearing at Woodstock? Perhaps they consider me a disciple of Alan Ginsberg and assume that I'm paying homage to his poem "Howl."

The moonlight is pouring through my pet humans' skylight over their bed—What a great time to show these guys how much I love them by honoring them with my wit and charm. Best way to do this is to jump on their bed and snuggle

up on one pair of legs and then the other. They pretend not to be amused, but I don't fall for it for one minute. Time for my inimitable "I belong here" stare. This really gets them quite animated, signifying real approval. I revert to meowing pathetically, pretending to be frightened by their antics. They buy it, of course!

They feel so sorry for me now they're apologizing profusely every time one of them has to move or twitch. "Are you okay, sweetie? I hope I didn't disturb you, precious." I've got them right where I want them! "Welcome home," I smugly congratulate myself.

Vanity Meets the Animal Communicator

Oh. Oh! Clearly, there was trouble in paradise. Why were my new pet humans being so solicitous? There was too much patting, too much tuna for breakfast. My ears went back as I tried to size up the situation.

Suddenly, the dreaded cage appeared from out of nowhere. The male human shoved me inside while the female tried to make soothing noises. Had I made a horrible mistake? What if they were taking me back to the animal shelter? Had I overdone my stunt of lying on their legs? Maybe they have bad backs.

They deposited me, ensconced in the cage, in the back seat of their new white Saturn. I reached down deep and meowed with all my heart. I hated cages. I hated cars. At this particular moment, I think I hated them.

The awful car backed out of the garage and then lurched forward. I felt carsick. Who invented these miserable automobiles anyway? Certainly, no one who liked cats. I clawed at the cage. I stuck my paw out and scratched their brand new back-

seat interior. Why were they doing this to me? What was going on?

They made reassuring sounds, but I had to find a way out of this terrifying roller coaster. Was yesterday just a wonderful dream? If so, today was a nightmare.

We pulled up to someplace I didn't recognize. At least it wasn't the animal shelter. They transported me into some building and deposited me in a little room. Shortly thereafter, a peculiar-looking human wearing cat ears and a tail presented herself. Now, I have lived in Santa Fe for all my life, so I know that in this most tolerant of cities, everyone has his own brand of eccentricity. A woman dressed like a cat is business as usual in Santa Fe, affectionately known as the "City Different." This particular Cat Woman began stroking my fur ever so gently. She had a nice touch; her hands were smooth and soothing, which made me feel a tad calmer. She continued this for about five minutes when, suddenly, the most bizarre thing happened. She started talking and was actually speaking my language. She explained to me, in my own tongue, that I was at the veterinarian's, getting shots for feline leukemia and other dreaded diseases. My new owners, she pointed out, meant me no harm. Au contraire! They had only my best interests at heart.

"That's why I'm here," she said, talking to me in the most lilting voice this side of my dear old mother. "I'm Alicia, the Animal Communicator. Your owners want me to assure you that you're safe and secure. I'll stay with you during your exam and explain to you what's going on."

Suddenly the door opened and in waltzed some chap in a white coat. "This is your new veterinarian, the best in town, I might add. He's just going to give you a little exam to make sure you're healthy." With that Alicia stepped aside and my new vet earned his keep. He poked around my entire body, checked my teeth, my fur, my paws. He had the unmitigated gall to check my private parts too. I knew he was just doing his job, but I, in turn, had to do mine. My task was to give his hand a little nip to indicate my irritation. Alicia came over to soothe me and said I was being a good girl. I decided against nipping her, although "good girl" is certainly an undignified way to speak to a cat.

It got worse. Another creature dressed in white, this one female, produced a long needle. Alicia quickly interceded and told me it was a shot for feline leukemia and was absolutely necessary. In my humble opinion, shots are never necessary. What had I done to deserve this heinous treatment? Everyone

was talking to me in soothing tones, but I didn't buy it. I yelped when I felt the jab, and gave everyone in the room my most hateful look. I'll bet this behavior would elicit no more "good girl" from Alicia.

Then all the white-coated humans with needles left the room. Alicia and I were alone. "There, the bad part is over," said the kind woman, flipping her fake tail with one hand and offering me some delicious fish-flavored crackers with the other. "Now we're going to have some fun."

I looked skeptical. "Your owners want you to be happy. They are very kind and decent people. They asked me to find out about all of your previous lives so they can treat you with the proper respect."

Talk about weird. Isn't there anyone in this loony town who hasn't succumbed to this New Age nonsense? If I had nine lives, I don't remember a thing about any of them. I was having enough trouble with this one, without going back through Past Life Therapy. But what the heck; I could handle this. I was a cat, wasn't I? I had an active imagination. I was creative. I was egocentric.

The Cleopatra theme came immediately to mind, having heard her name bandied around by any number of humans,

including my ridiculous erstwhile owners. It seemed that Cleopatra had an enormous following of people who are now in their tenth incarnation. I joined the group of lemmings at the edge of the water and threw the Queen of the Nile's name into my past life pool.

"I was Cleopatra's favorite cat," I explained. "I had my own set of servants, my own pyramid cat house, and all the Egyptian mice I could chase. I had a special waterproof seat on the barge, and Cleopatra never went cruising down the river unless I was seated by her side. This present life has been a little unsettling, what with the animal shelter, confining cages, and pointy needles," I confessed, helping myself to another fish-flavored treat.

I really threw myself into this charade by pretending to go into a trance. This is not too much of a stretch for a cat. After the appropriate five-minute interval of staring dopily into space, I blinked three times, just to evince the proper amazement.

"I knew my present owners in my past life," I announced with just the right touch of drama, all the while switching my tail. "They were mere barge drivers, slaves of my darling Cleo." I couldn't resist hamming it up, so I added, "One of them acci-

dentally splashed Cleopatra. She was on the verge of having them put to death, but they had always been kind to me so I successfully begged her to spare their lives."

"I'll see that you are treated with the proper amount of respect," the Animal Communicator said, giving me a deferential bow. "I'll inform your owners immediately that you were once The Sacred Cat of Egypt and that you deserve to be treated accordingly."

I bid her farewell and commenced licking myself, as befit my new station in life. After all, if these gullible galoots thought I was Bast, the Egyptian cat goddess, I was going to milk it (as it were) for all it was worth.

Vanity Takes on the Art World

It's late fall, almost Halloween, and winter is in the air. Usually, at this time of the year, I would have been working on my Halloween outfit, but I was too preoccupied even to think about a costume. You see, today was the beginning of a whole new career for me. My female pet human, whom I have named Mickey, has a job as the curator of the Fine Arts Museum. She came up with the most extraordinary offer last week. She asked if I would be willing to serve as a docent. You bet I would!

It seems that a group of animals had gathered outside the museum protesting that their point of view had never been represented by any Santa Fe museums. The protestors, as they are wont to do, gave the museum an ultimatum. They warned Mickey, in particular, that if the museum didn't get some four-legged tour guides soon, they were going to shut down the whole operation. The Animal Rights Foundation (ARF) threatened the museum, a pugnacious group of animal hecklers guaranteed to create mayhem and generally make the museum

experience totally unpleasant, if their demands weren't met. In the interest of museum attendance and political correctness, I was made the first animal docent.

I fussed for some time over my wardrobe. I am very purrsnickitty when it comes to my ensembles. I wanted to look rather avant garde but at the same time dignified. I decided that white gloves were too much like the fifties and much too Midwestern. Besides, I had my own set of built-in gloves. After much trying on and tossing aside, I settled on the purrfect outfit — a long string of pearls and a black and white floppy hat that matches my fur. If I do say so myself, and modesty does not forbid, I looked stunning.

I sauntered purposefully to the Plaza to get to my post in time and to give myself a proper licking before the crowd gathered. And what a throng this was—the word must have gotten out that this was to be an animal-friendly lecture. There was a good turnout of cats and dogs, along with a smattering of bunnies, several pigs, and the obligatory hummingbird. This being Santa Fe, I was pleased to see a good turnout of some of our native animals—a colony of prairie dogs, five burros, and two roadrunners. To cap things off, there was the customary large human population. Doing our best in the interest of

political correctness, we had found translators for two of the species. We had to move quickly, so we were unable to find rabbit and hummingbird interpreters. To show our sincerity in representing the underdog, as it were, we even had the Southwest's finest Doggerel expert and an international authority on Pig Latin.

As you might expect, I weighed my talk heavily in favor of felines. With great pride, I pointed out to the eager crowd the museum's new portrait by the one and only Clawed Meownet. As the excitement built, I unveiled a little known but excellent painting of Abiquiu, Georgia O'Keeffe's cat, painted by the artist herself. My personal favorite of the tour was the little known portfolio of photographs of Navaho cats by Laura Gilpin.

A hush fell over the crowd when I announced that I had just convinced the Acquisitions Committee at the museum (of which I am a member, of course) to add a *Picatso* and some furniture from the Bowwow Haus to our sterling collection. A round of meows, barks, and high-pitched chirps gave me the "paws up" on my choices.

The group seemed most enthusiastic about a recent painting of a cat's eye view of Santa Fe by Paul Calico. It looked like Brueghel's impressions of cat life in Santa Fe complete with

colorful animate objects that were so lifelike they practically jumped off the canvas. One of my fellow tabbies tried batting at some of the mice. The turquoise-and-coral drinking fountains for cats in the painting were so inviting-looking that I yearned to lap some milk (or at least some water) from them. My favorite details were the silver and onyx cat perches strewn throughout the downtown region. In a moment of spontaneity, I suggested to the crowd that the city fathers and mothers should consider reinstating these comfortable looking perches for today's cat populace. One pussycat on my tour was especially enamored of the sculpture in the middle of the painting depicting Santa Fe's First Cat, *El Gatón de Don Diego de Vargas en la Villa Real de Santa Fe de San Francisco de Asis.*

My first docenting experience seemed to be going purrfectly. I hummed contentedly and was even planning some new surprises for the next tour of duty when I caught a glimpse of a mouse scurrying around the floor. Before I knew what had happened, I tossed off my pearls, threw my hat to the wind, and was down on all fours having a go at the stupid little rodent. From there, it only got worse. All the other cats wanted to have a shot at the mouse. This frenzy of activity seemed to rouse the dogs who started chasing the cats. The hummingbird was all

a-twitter and impaled a bright red section of an R.C. Gorman painting.

Suddenly a bell went off inside my head. What was I doing? I had my reputation as a docent to think of, the honor of the museum, the sincerity of political correctness. Mickey was regarding me with a look of amused horror. How could I have let her down? More important, how could I have let myself down? I am, after all, a dignified cat, not some ill-bred creature from an alley.

I pulled myself together and gave myself a quick grooming. I gathered my composure along with my pearls and hat and managed to go on with my lecture. The humans seemed slightly bemused by my performance, but the animals, being more sensitive, listened politely and intently while I finished my docent duties. I was once again the perfectly refined feline. Thus was another catastrophe avoided!

Vanity Becomes a Glamour Puss: Adventures at the Cat Spa

It was almost Thanksgiving. Snow covered the Sangre de Cristo Mountains as I made my way to the legendary New Mexico Cat Spa. I know that you're probably wondering how I could possibly be any more beautiful, but trips to cats spas have more to do with hedonism than beauty. Let me explain.

Even though my anticipated manicure, pedicure, and combing may add to my overall magnificent appearance, the Santa Fe Cat Spa is simply another opportunity for me to plug into this indulgent New Age Santa Fe phenomenon and to let these naive humans treat us Goddesses with the respect that is our absolute due.

I owe my marvelous makeover to Alicia, the Animal Communicator, the greatest friend to animals since St. Francis. Alicia had convinced Mickey that my past lives had been ever so luxurious and that in this present incarnation I had suffered

greatly and therefore deserved a treat. Mickey was giving me this special indulgence as a Thanksgiving present.

So, to the Cat Spa we came—and shut my mouth and curl my whiskers, what a deal! Keeping up with this Bast Ancestral Heritage thing was certainly serving me well.

I felt a little guilty (but not much; guilt genes are just not part of our makeup) as we drove to Pecos, for I fear that I had to deceive Mickey. Alicia had patiently explained to me where Mickey and I would be going, so I wouldn't experience any anxiety about the scary car ride. Just to keep Mickey on her toes, though, I yowled piteously on the way out. I wasn't totally doing my *Cat*herine Hepburn routine, because whether humans realize it or not, cars do make cats a little carsick.

Mickey kept apologizing, assuring me that when I saw what was in store for me, I would forgive her this hideous ride. Just to evince every ounce of guilt possible, I pretended I was in the Yowling Olympics and with each one of my pathetic howls, Mickey promised me yet another spa treatment. It's no accident that felines are neck-in-neck with Jewish mothers in the guilt department!

By the time we arrived, Mickey was feeling so contrite that she promised me the "Cat Ballou," the most deluxe package available, the whole beauty enchilada.

To put me in the proper mood for my treatments, I was taken first to the soothing Bird Audiotherapy chamber where I alternately chattered and gnashed my teeth to the sounds of a Bluejay trill, a Rufous Hummingbird serenade, the House Finch Fugue, and Two Robins singing a duet. Then I was placed in a pleasing Aromatherapy Chamber where the delectable smells of catnip and caviar catapulted me into Cat Nirvana.

This catalogue of earthly delights kept unfolding. A beautiful dish of "Mystical Milk" (actually it was cream mixed with some soothing herbs — none of that anemic 2% milk at this classy joint) was placed before me. Soon, I drifted into a lovely catatonic stupor. In this dreamlike state, I was given a facial with special Santa Fe spiritual dirt. This magic mud soothed, stimulated, and sparkled. While I drifted in and out of slumber, I heard my facial therapist tell me that this dirt had a long history of soothing frantic New Mexico felines—D.H. Lawrence's cat, Lady Chatterly, and Willa Cather's cat, My Antonia, were but two of these.

Next came the Aura Balancing, which sounded really silly and New Age—just the type of absurd woo-woo thing that Santa Fe specializes in. Before I knew what had hit me, some goofy-looking woman named Sioux Casa entered swinging crystals and incense for all she was worth. She had on a dirty short denim skirt that would have barely covered Minnie Mouse's private parts. Because Sioux had a figure that more resembled Dumbo, the skirt looked like a napkin. Her gauzy white see-through blouse (no bra, of course) was accentuated by a torn, faded pink Bandana. She sported a crystal hair barrette, crystal ankle bracelet, and matching crystal necklace. Sioux looked as if she were on her way to a Halloween party, but I've learned after living in The City Different my entire life, that in Santa Fe every day seems like Halloween.

The whole act (an anagram of cat) was hopelessly shabby, but after I heard what she had to say, I could have cared less if she was on Mr. Blackwell's Worst Dressed List. This woman was proving to be my friend and ally.

When Sioux told me to take a deep breath and to delve deeply back into my past lives, I stared vacuously into space, thinking deeply about what was on the lunch menu at this fancy beauty shop. Sioux started muttering some incantations over

my head while I conjured images of sushi and chopped liver. "Ahhh," she murmured. "Just as I suspected. Dead mice in your third chakra—a very auspicious omen."

This food channel that I had plugged into seemed to be doing me no harm. The elegant chow I visualized seemed to be producing a rather splendid Aura. Sioux Casa, doing a little dance around me, sputtered that my Aura was purple, the color of royalty. I guess this was because I was dreaming of poached salmon with hollandaise sauce as a dinner entree.

Then suddenly with a gasp and a horrified sigh, Sioux transmogrified into a combination of The Wicked Witch of the West and The Dalai Lama. She chanted, she cackled, she swung crystals over my head. She burned 31 flavors of incense. I was new at this business, but I could tell that something was troubling this psychic.

"Ahh, it's just as I feared. There is a black and blue cloud in your eastern Aura." After some contemplation and more noisy chanting (which was interfering with my sleep and food dreaming), she attributed this dark spot on my Aura to my unfortunate stay at the animal shelter and the callous treatment by my former owners.

"There is only one solution," she announced dramatically. "Bring in the mice!" she demanded of her assistant, Now, I have batted some mice in my day, but I must say I have never seen mice so ceremoniously decked out—quite a contrast to Sioux and other human counterparts. The Three Mice (who could see quite well, by the way) looked as if they had just hit the jackpot at Santa Fe's annual Indian Market. They had on matching turquoise, coral, and onyx necklaces with tiny fetishes of sacred Santa Fe mice on them. They all sported the obligatory silver concho belts, turquoise bandanas, and three identical cowboy hats.

I batted, they ran. It turns out they were all trained in karate, so we sparred a bit. I found out later that they were professional acrobats, so when I batted them, they made it ever so much fun by rolling themselves into balls or leaping up in the air. The Cat Spa was approved by the Humane Society, so no killing or injury was allowed. All in all, the whole cat-and-mouse game was a great workout.

Sioux informed me later that the mice are employed as personal trainers and the workout serves as an aerobic class for overfed felines like me.

The rest of the day was sybaritic at its very best. After the mice workout, I rested for a while in the Ancient Anasazi Sun Spot Room where a choir of mystics intoned something about the ancient powers of the Anasazis and Mayans. I didn't pay much attention because it was nap time, so I don't know if the Sun Goddess in charge of the room was Anasazi, Mayan, or Españolan, but never have I felt such soothing, intense sunlight. I saluted the dame with a sun salutation exercise before settling into my mid-afternoon sun bath. This Cat Spa was all right!

Vanity Hits the Slopes

It's my favorite time of the year—winter. It's almost Christmas and there's good cheer and snow in the air, which, in turn, means hallelujah, it's finally ski season.

You know that I don't like to brag, but I must admit I am a dynamite skier. More to the point, I am a natural-born athlete and I do like to stay fit. I have a trim tummy without an ounce of fat anywhere on my sleek body. One of the ways I've remained in shape in the winter is by making weekly ski expeditions to Taos.

My skiing mentor and companion is Jean Clawed Kitty. He is a former Olympian, and I couldn't ask for a more masterful teacher. J.C., as he likes to be called, is an elegant and courtly fellow. We make quite the handsome couple.

Jean Clawed is a dapper Russian blue with a magnificent, shiny grey fur coat, which is the envy of every feline who encounters him. His eyes are an intense green and he seems to

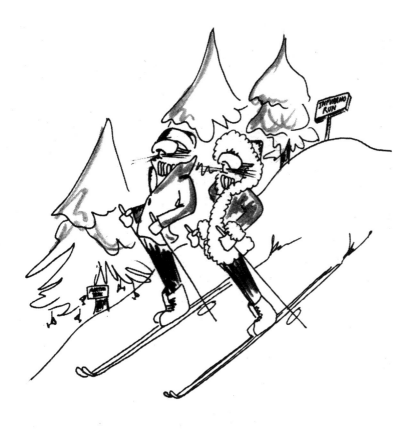

look right through you. He has a Hercule Poirot French mustache, and his trademark is a jaunty red French beret. He purrs with a thick French accent and entertains in a local cabaret singing sexy French ballads.

Jean is a dashing gentleman whom I am proud to call my friend. He has a certain *joie de vivre* and a strict code of honor. As you might suspect, J.C. has some hard and fast rules on skiing, a catalogue so to speak. Humans may apply what seems to fit.

Rule Number One: Inner skiing begins with outer clothing. You are what you wear. One of J.C.'s friends from the Olympics was a fashion ski designer. Because we ski in tandem, J.C. had outfits designed for both of us. We wore black skintight ski pants with snappy red jackets, complemented by a red spandex ascot. A red beret (just like J.C.'s) brilliantly accented my black, brown, and white fur coat.

Rule Number Two: Avoid falling at all costs. Jean's cardinal rule of feline skiing is, "Remember that snow is just frozen water!"

Rule Number Three: Only go skiing where they serve Hot Milk Toddies. J.C. and I frequent the Martini Tree cocktail bar at Rhoda's Restaurant. Their milk toddies are *wunderbar*.

Rule Number Four: Always pull your tail up before getting on the ski lift. Kitties who have been caught in the chair have cold tails and sad tales of lost tails to tell.

Rule Number Five: Beware of Snow Cats. In spite of their comforting name, they are not one of us or even our friends. They are mechanical, fiendish contraptions used by humans to make noise. Stay out of their way.

Rule Number Six: Don't forget to skate on the catwalk. Jean Clawed and I helped design it and it is very fetching.

Rule Number Seven: If you are an aspiring screenwriter like most cats in Santa Fe, don't be misled when you hear that you can meet some big moguls in Taos. These moguls won't help your career but could bump you into a body cast—be careful.

Rule Number Eight: Al's Run, Lorelei, and Kachina Peak are all splendid trails, but a little known fact is that Infurrno is the run especially prepared for feline schussing. Jean Clawed and I named it and laid it out ourselves, so it is purrfect.

Rule Number Nine: St. Bernard Lodge is reserved exclusively for canines while felines are welcomed with open paws at Thunderbird Lodge. For a $10.00 fee, Thunderbird will provide you with bird videos, bird toys, and on special occasions a few

live birds to chase around the room. Mixed marriages (those between cats and dogs) stay at the tolerant Inn at Snakedance.

We can talk all day about skiing, but the thrill is actually doing it. So if you'll excuse me for a moment, I'm going to hit the slopes. Nothing puts you in the catbird seat of life like a good run down the hill.

Write On

It's February and quite nippy outside. In this weather I like nothing better than cozying up to the warm fireplace glow. This cold snap has sent Mickey to her computer, where she is writing her first novel. I got my first taste of the writer's life when I helped her with her opus. Mickey seemed to be struggling so and was constantly telling Larry (I did tell you that I named him Larry, didn't I?) and me that she just didn't have time to finish the task. So, being the wonderful humanitarian that you know me to be, what choice did I have but to help her?

First of all, after Mickey told me about how lonely writing could be, I thought the least I could do was to keep the poor woman company. I served as divine a muse as ever lived by cuddling up on Mickey's laser printer. My fur kept the whirring machine warm and fuzzy. Sometimes, I would jump on Mickey's computer and meow upbeat slogans designed to keep my would-be author inspired and encouraged. "You can do it," I cheered. "Move those claws (oops, fingers). Write that book!"

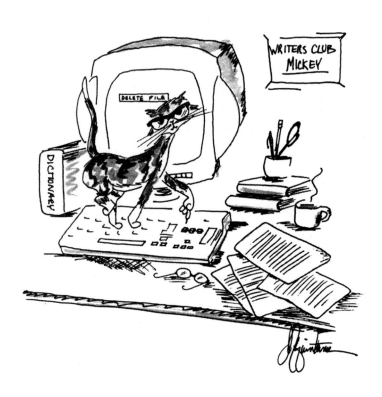

Mickey seemed to appreciate my efforts, although she was easily diverted. She kept vacuuming the laser printer, muttering something about hair being caught in the mechanism. I have no idea of what she spoke, but I do know that writers are always looking for excuses not to write. I suspect this hair thing was just a stalling technique.

One day, while Mickey was at her day job at the museum, I decided to surprise her by finishing the novel for her. Wouldn't she be thrilled? I don't know what all her suffering and sighing was about because, to me, writing is a piece of cake. I simply pranced up one set of keys and danced down the other. In no time at all, the tome was completed.

Just before I had hit the keys for the last paragraph, I saw this note that said, "Are you sure you want to delete this file?" I'm pretty sure it was a cryptic communique coming through the system from a publisher (computers are so fast these days) saying, "Vanity, you're brilliant, undoubtedly the finest writer since Shakespeare. Of course, we will publish this book."

Mickey shrieked when she saw what I had done with her novel, but then you know how over-emotional these humans can be. She seemed overcome — wait till I tell her about the note from the publisher. Since this task is a humanitarian

gesture, I am going to let Mickey keep her name on the book. That's just the kind of selfless being I am.

I thoroughly enjoy this writing business, and, in my usual methodical style, I have done considerable research. I was somewhat shocked to discover that many writers spend lots of time writing books on the subject of teaching other writers to write. It seems a trifle foolish to me because, after all, aren't you just creating more competition for your craft? But I am well on my way to becoming a master at my trade and found most of these books too complicated and pretentious. Ergo, I present you with:

Vanity's Rules of Writing:

1. **The key to good writing is careful prancing**. Writing is a dance, a glide, a Strauss Viennese waltz along the computer keys. Don't think, don't plan — just jump and create.

2. **Keep in mind that writing is a tactile art.** One of my personal favorite forms of expression is chewing the paper to add an artistic statement. Some authors say, "Dive into your work." I say "Bite into it" or "Get your claws into it!"

3. **Be original—Create your own language.** Think of yourself as the James Joyce of the Cat World.

4. **The protocol for writing in restaurants — DON'T!** Restaurants are for dining, not writing. Besides, if you write in a restaurant you miss the fun of prancing on computers and creating new words, new sentences, new worlds. Prancing in restaurants is considered a faux paw.

5. **Remember that writing, like all feline activities, is about instant gratification**. Don't plan, don't plot, LIVE!

6. **Revise, revise, revise — CERTAINLY NOT!** This approach stifles creativity — instead it's improvise, improvise, improvise!

7. **Keep your public begging for your next book**. Writing too much is bad for your image and interferes with sales. Bear in mind that too much time spent in writing cuts into your nap time.

Vanity Goes to the O'Keeffe Museum

Very few humans know what we felines have always known — that Georgia O'Keeffe was one of us. Just take a look at those beautiful, slanted, catlike eyes and that gorgeous neck and straight spine. That elegant woman, the grande dame of the art world, was obviously a cat in one of her many lifetimes.

This little known fact is why we cats adore O'Keeffe and her work. It's why I'm the chairwoman of the board of directors at the new O'Keeffe Museum in Santa Fe. I'll let you in on another secret. We cats are reluctant to brag, but did you know that "The Society for Cats Who Paint" catalyzed the movement to give our gal, our mentor, her very own Santa Fe museum?

Who do you think raised all the money for the O'Keeffe Museum? Certainly not the boorish Canine Community.

Let me take you behind the scene of the Gala Opening for the museum's benefactors, "The Society for Cats Who Paint."

As I strolled into the magnificent museum, and perused the spectacular art work, my heart almost burst with pride. The

gallery was filled with the top sophisti*cats* of the feline world. Our special guest of honor was Abiquiu, III, the granddaughter of Ms. OKeeffe's favorite cat, Abiquiu the First. I must say that Abiquiu looked stunning, almost as breathtaking as yours truly. You know how it is said that humans grow to look like their pets. Well, this certainly was the case with Abiquiu. She resembled a miniature O'Keeffe with her beautiful, slanted green eyes and long sleek neck. She was an aristo*cat* and everything in her demeanor said good breeding. She was dressed in a black cape and a black hat that purrfectly matched her shiny black fur. Some of the Buddhist cats who believed in reincarnation exclaimed that Abiquiu was Ms. O'Keeffe joining us for the opening.

As for me, because it was early April and spring was right around the corner, I was decked out in a lavender and green tea-length gown that perfectly complemented Ms. O'Keeffe's *Petunia* II painting.

I shouldn't let this cat out of the bag, I suppose, but I happen to know that Ms. O'Keeffe had my coloring in mind when she painted this picture. My grandmother (of whom I am the spitting image) visited Ms. O'Keeffe and Abiquiu quite frequently. She posed often for the great artist and O'Keeffe told grand-mère that her exquisite coloring inspired her. She

revealed that even when my elegant grandmother wasn't in residence she would envision her and paint in hues that would complement her brown, white, and black coloring.

Prior to my commentary on the art treasures that hung on the wall, we enjoyed the obligatory cocktail hour. I had planned all the goodies and I must say I was pleased with how well the soiree turned out. The huge Waterford punch bowl was filled with milk punch. The attractive waiters from Caters to Cats, dressed in black tuxedos, passed the hors d'oeuvres to the hungry but well-behaved hordes. (I have found in Santa Fe it is useless to try to get down to business until food is devoured.) And what a spread it turned out to be — blue corn blini with smoked salmon, crab quesadillas, avocado and shrimp terrine, and green chile wontons.

After sating our dainty appetites, I groomed myself (I have to live up to my name, you know) and began my presentation. Many in the crowd set up their easels and began to sketch—after all, Georgia O'Keeffe was our mentor, and we are "The Society for Cats Who Paint."

My speech, entitled "How Ms. O'Keeffe Should Inspire Cats Who Paint," had the audience, even those painting, listening in rapt attention. "Society members, we are here today to pay tribute to our inspiration, Georgia O'Keeffe. Besides being

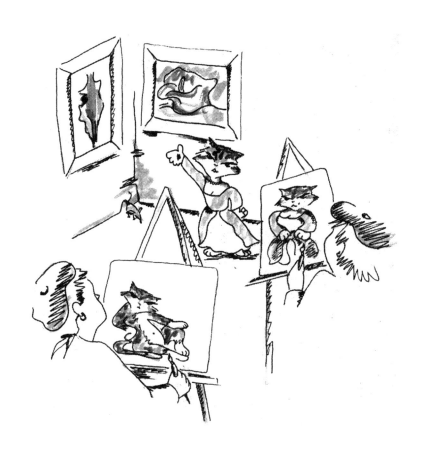

the foremost painter of her generation, she was the foremost inspiration for Cats Who Paint." I paused for the roaring applaws and the approving round of soothing purrs.

"What can we learn from Ms. O'Keeffe? We can follow her example and do whatever we want, whenever we want. Defy convention. Follow your heart. Live. Live. Live. Paint. Paint. Paint. Practice every day and everywhere. Surprise your humans with a fresh painting on their living room wall. Don't be alarmed if they shriek and scream, for that is their way of showing delight.

"Take inspiration from Ms. O'Keeffe's shapes — don't they look like mice? Bat the images around in your mind and put them on the canvas. Think of how many of her images look like fish bones. How about the skulls — wouldn't they be fun to chew on?"

I paused for another round of purring. "Have you ever meditated on her pictures of clouds? I assure you they will put you in the ideal catatonic trance.

"Her flowers and doorways have special meanings to cats — don't you just want to jump in them and hide?"

Unfortunately this suggestion inspired two of the cats to take me too literally. Their attempts to dive into O'Keeffe's *Patio*

Door with Green Leaf didn't do the painting any harm, but the cats hurt their heads and were temporarily stunned. I always forget how powerful my speeches can be! I decided I had better close my remarks before more kitties began prancing from cloud to cloud on my favorite painting, *Sky Above Clouds* I.

We always close the Society's meetings with a few moments of oohing and aahing over each other's works. I asked the painters to turn their easels so that I could see them and I was stunned to discover that every artist had painted pictures of me, instead of imitating the spectacular O'Keeffe works. It's not often I am rendered speechless, but this was such a moment. Everyone roared (there are many lions in our organization) and purred in unison while I modestly bowed to my adoring crowd.

A Night at the Opera

My night at the opera started off rather innocuously. My confidante Aria and I were all a-twitter at the prospect of attending the July gala opening of the Santa Fe Opera, the quintessential soiree of the season. As we tried on our outfits, Aria made catty remarks about some of the singers we would be hearing. As you may have guessed, Aria owns an opera singer; besides getting box seats every year, she is privy to some of the choicest gossip about the music world this side of Lincoln Center. I learned who was sleeping with whom and got wind of who had already alienated the Maestro, The Great Catsby. It was like having a private edition of *Entertainment Tonight*, Opera Style, in your own backyard.

Opera is a passion of mine and I've always been a trifle miffed that there is not a special opera performed by cats. Okay! So there's one Broadway musical about cats, but is that supposed to take care of all the musical disciplines? C'mon— it's a grotesque injustice.

With all due modesty, I have a magnificent bell-like voice and would make an exquisite diva. I certainly have the right temperament. I sing all the time around the house and, by all accounts, am extremely entertaining. This opera aficionado bit goes way back to when I was just a grace note of a kitten. My mother used to purr us to sleep at night with selections from La Boheme and Lucia di Lammermoor.

After hours of discarding clothes that just wouldn't do, I decided to go native and adopt a Santa Fe look. In an old trunk in my pet humans' guest house, I found just the perfect white cowboy hat. I decorated it with a silver concho belt on which cats served as the conchos. I then borrowed my owner's fetish necklace consisting of twenty different species of cats, with each stone a different color. I located my pair of black and white boots that I had commissioned from Tom Taylor exclusive boots. To top off my regalia, my female owner offered me her turquoise silk Coyote-style bandana.

When the big night finally arrived, my owners drove all of us to Tesuque, the beautiful site of the Santa Fe opera. I felt my chest swell with pride looking at my pet humans. Mickey wore a stunning Adrienne Vittadini black silk pantsuit that I had been admiring lo these many months. Miraculously, she had

managed to remove all the cat hairs! Her accessories of exquisite pearl earrings, a long pearl necklace (mine, I think), and a pearl bracelet were perfect. Larry, who hardly ever wore anything but T-shirts and jeans was truly handsome in his white silk jacket with a pale pink tie. As you may have noted from my fashion commentary, I am somewhat of a clothes horse (if you'll pardon the expression). This is rather unusual for a cat, but I remain *au courant* on *haute couture* by subscribing to *Catmopolitan*, *Vanity Fur*, and *Meowabella*.

Aria was in peak clothing form herself tonight. She looked stunning in her full-length, silk periwinkle blue gown; the diamond tiara might have been excessive on some cats, but Aria had the nose and whiskers to pull it off.

Lest you judge us to be completely shallow critters who think only of our external beauty, we did spend an equal amount of time selecting our evening's cuisine. To get into just the proper mood for the opening night's festivities, we had packed a tailgate picnic, which for us felines was quite appropriate, you must admit! Mickey and I had spent many days consulting on just the perfect menu for both the feline and human palate. I have pretty sophisticated tastes, so we concurred on the following victuals, southwestern in style: rabbit

liver with roasted apples, turbot and tuna with crustades of black olives and smoked tomato-butter sauce, grilled lobster tails stuffed with deviled shrimp in brown sauce with tamarind, and smoked crab. The desserts were loaded with heavy cream. I could hardly wait to lap up the fresh-berry mousse in pizzelle-cookie bowls and southwestern fruit flan with prickly pear glaze.

My owners parked their unassuming Saturn in the huge parking lot at the opera ranch, where we were soon joined by a host of other merry makers. It was a most splendid affair. The July night air was crisp and invigorating. At 8:00 P.M., the sun was setting majestically over the Jemez mountains, turning the sky a pink-orange hue. All of this complemented Larry's tie very nicely.

Champagne flowed. I purred contentedly as I delicately chomped on the liver with roasted apples and lapped my champagne. Ah! What food! What drink! What owners! What a town! What a life!

This was our first trip to the newly remodeled opera since the powers that be had added the enclosed roof. I must say that, at long last, the place is extremely cat friendly. Prior to the announcement last year that the July rains would finally be kept at bay by the new roof, the Feline Opera Guild had been

considering a boycott of the opera. As the guild's president, Diva, put it, "Having wet fur is so unpleasant and undignified!"

When Aria and I went to the newly remodeled female cat box, we were thrilled to see no line at all. In the past, it was ever so humiliating standing in that hideously long line trying to use the litter box in between acts.

By the time we strolled to our seats at 8:45, the blending of the twinkling stars and the sparkling lights of Los Alamos seemed to lead our way like some magic wand. The opera for the evening was *The Duchess of Malfi*. I was quite irritated when I heard some insensitive slob in the next row comment that the music sounded like someone stepping on a cat's tail. I offered the offender a "We are not amewsed" look that would have been worthy of Victoria herself.

At intermission, I overheard more remarks from audience members to the effect that *The Duchess of Malfi* was atonal garbage. Many people left, none of them humming any of the arias from Act 1. As for myself, I was thoroughly enjoying the opera, so I couldn't empathize with these malcontents.

I was distracted from the opera commentaries when Aria tossed me some outrageous catnip. I have to admit we both got pretty silly. I had warned myself in the past not to do catnip in

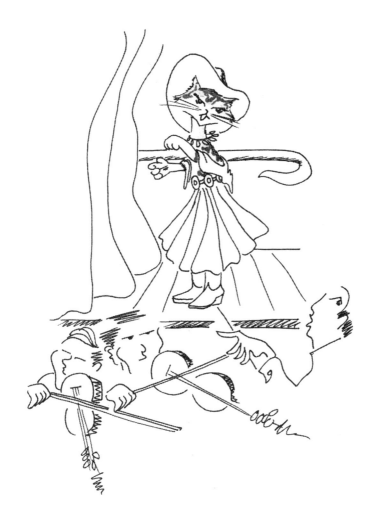

public, but it was such a festive evening that I couldn't resist the stuff.

Just as the second act was starting, something snapped inside me. Perhaps it was the catnip. Maybe it was the opera. Possibly it was because Mercury was retrograde, as my previous owners and other New Agers always claim. Whatever the cause, I just knew that I had to sing. It was an urge I couldn't resist. One moment I was humming along rather innocently. The next thing I knew, I had burst into song and leaped up on stage. Suddenly, I became part of the opera.

I was like a female possessed. I pranced back and forth across the stage, yowling my little heart out. I couldn't have told you at that moment where I was. All I knew was that I was fulfilling a lifelong dream. I was on the stage singing opera in front of an august audience.

Everyone really seemed to be enjoying my performance. I don't always understand the nuances of the human language, but I did recognize someone shouting out, "What's that cater-wauling?" which I interpreted to mean, "Let the cat have a bigger role." I curtsied to the well-wisher and sang all the louder. By now, I had the crowd in the palm of my paw. They apparently didn't think I had consumed enough food during the

tailgate picnic, because suddenly they began throwing cheese, chunks of lasagna, tomatoes at me. Even though I was quite full, I couldn't resist sampling the Brie and the lasagna. They were quite tasty, although I really didn't care much for the overripe tomato.

It didn't seem quite fair to my adoring public, however, for me to spend any time eating when I should be entertaining them with my lovely voice. Just as I was belting out one of my loveliest arias, a hook appeared from nowhere and magically deposited me backstage. As a trooper actress, I knew that this meant that my part in the opera was complete. This was all part of the plot. Backstage, excited looking directors and singers were screaming something like "Get that cat outta here." I couldn't make out all the words, but I'm pretty sure they meant, "Get that cat a tiara," or something equally magnificent. I meowed demurely with my "Aw shucks, it was nothing" routine and sauntered gracefully back to my seat. What a glorious evening. A night at the opera is so good for one's soul!

Vanity Attends a City Council Meeting

If you want to see the real Santa Fe, forget the glamorous place you read about in *Condé Nast Traveler*. To discover what really makes this town tick, you have to go to a City Council meeting. Let me tell you about the one I attended last night.

The place was packed to the rafters, and I could tell that it was going to be a long evening. Fortunately, I had brought along a canteen of double espresso latte, so I was all set. First on the agenda was Pedro Prairie Dog, who argued passionately about having a park set aside for his colony. There was a raucous discussion between the prairie dogs and their human friends on one side and the opposing team of developers. In the best Santa Fe fashion (borrowed no doubt from *Alice in Wonderland*) the motion for the park was tabled until the next meeting. My good friend, Felix Catanach, the Ben Franklin of our fair city, reminded Pedro that the council's motto is to act cautiously, and postpone whenever possible. Felix smiled directly at Pedro and knowingly assured him that the council would eventually

get to his issue. Pedro, who had moved to the City Different from Colorado, looked bewildered.

Next on the agenda was Benita Burro who requested a zoning change to build new stables for her family. It might seem like a simple enough request, but Benita lived in the "historic district" and her proposed new roof was slated to be Nouveau Territorial, rather than Old-style Territorial. She was asked to submit an architectural drawing for a roof that was historically correct to the Planning Commission two months hence.

Conchita Chihuahua had her turn next and in a very sweet, coquettish fashion, argued for more gentle treatment and better roadside manner from the dogcatcher. At the very name dogcatcher, all the canines, even the prairie dogs, collectively growled and shrieked, and a few told tales from the barkside. A motion was made to form a committee to study the dogcatcher issue more thoroughly.

At this point, a whirring hummingbird flew up to the microphone. "What's with this council? I've been attending meetings for the last six months since I've migrated here from Mexico and you've always been, shall we say, indecisive. What gives?" she asked, flitting around in a dither. "When was the last time this governing body acted on anything?"

This was my cue and the reason why my friend Councilor Sam Katz had asked me to attend this evening's meeting. Sam, decked out in a white cowboy hat to prove that he is a good guy, said in his most pleasing voice, "Well, of course, we pass lots of things here. But don't take my word for it. I call to the podium Ms. Vanity Cat."

I calmly strolled to the podium, feeling very professional and businesslike in my black and white suit and matching hat. I groomed myself for a moment, cleared my throat and stepped up to the microphone. "Exactly a year ago, it was my very great pleasure to be the sponsor of The Siesta Law, Ordinance 14A.1.37- 929." With great pomp and circumstance, I pulled a copy of the bill from my matching black and white briefcase. I put on my black, white, and brown reading glasses and described to the skeptical crowd The Siesta Law, which states that any feline in Santa Fe county has a right to snooze in any shop, hotel lobby, tourist's lap, or other public place between the hours of 9 A.M. and 9 P.M. The felines in the audience (and I had seeded the crowd with many of my best friends) let out an approving round of purrs and meows while high fiving each other paw to paw.

I felt I was on a roll, and so, to Sam Katz's surprise, I pulled another piece of paper from my briefcase and announced ceremoniously: "My fellow felines and I humbly thank you for passing the Santa Fe ordinance 929. It has been such a success that I would like to propose another law making it illegal to have dogs on the plaza between the hours of 1 to 5 P.M. This alloted time would be for cats only."

As you might well imagine, the fur started to fly. A barrage of Doggerel emanated from the Canine Contingent. The usually well-behaved feline faction responded with some cat calls of their own. What had I unleashed?

In the midst of all this chaos, Peter Piglet, the Parliamentarian of Procrastination, took charge. "Please, peace, proper procedure," cried this pied piper of alliteration. He banged the lectern with his gavel. "This is Santa Fe, the City Different. We don't fight. We don't argue. We postpone. Peace through procrastination is our way. I move that we table this motion till next month. Hopefully you'll forget about it by that time."

Vanity Takes a Cat's Eye View of Los Alamos

My humans, Mickey and Larry, are the most considerate of pets. Whenever there is a problem in the household, they try to shield me from it. They whisper about it or try to pretend that nothing is wrong.

But Vanity the Magnificent knows all and sees all. So today when Mickey got out all her bills, played with the calculator, and broke into loud sighs, I knew there was trouble in paradise.

I am quite the master detective, you will note. Nancy Drew has nothing on me. I jumped up on Mickey's desk and sat on the stack of bills. She usually finds this act of gymnastics amusing. I enjoy biting her pen while she is writing. Finally, to get fully into the swing of things, I roll around on the desk, scattering the papers hither and thither.

Now, this is where being the skillful detective comes in handy. You probably think this is just part of my playful adorable kitty routine. But no! Rather, it is a careful ruse to discover the origin of Mickey's despair.

As she added up the figures yet again, I perused the accounting situation and noted that most of these invoices were marked "overdue." Hmmm! Not at all like the extremely responsible Mickey.

I purred reassuringly and she petted me. I decided it was time for a heart-to-heart. I crawled on her lap, purred my loudest, most comforting purr, looked up at Mickey and asked, "What's wrong?"

"Don't you worry, Vanity," she said, folding up the bills and putting them back in the "To Pay" basket on the desk. "It's nothing."

She was lying, of course. I revved up my motor some more and licked her hand. Tears formed in her brown eyes.

"Can I help?" I mewed.

"Oh Vanny," she said, calling me by my nickname. "I've lost my job."

I must have looked worried because she quickly said, "Oh, don't fret. Your lifestyle won't change. You'll still have your salmon quesadillas every Thursday."

"What happened?" I inquired, gently licking her other hand.

"The art museum didn't get their Title 2000 grant. My job was the most dispensable," she answered, wiping her tears on her shirt sleeves.

"Federal arts cuts, I bet," I added, while allowing her to play with my white tummy. This always relaxes her.

"There was a big article in last month's *Art News* about the fat cats in Washington slashing the budget."

I tried to change the subject and put a positive spin on things. "But now you'll have time to work on selling your novel," I said in my most tranquil voice, purring all the while.

"It just got rejected again," she sighed, tickling my chin.

I decided that with Mickey in this agitated state, now wasn't the best time to remind her of the publisher I had found for her on the computer.

"Besides," she said with tears softly falling on my fur, "the pay for first novels is dreadful."

Humans have constructed a peculiar society—it seems to take two of them to support a single household. I have never understood why someone doesn't pay them to take more naps.

Thinking of the aforementioned peculiar mores of Homosapiens and simultaneously reflecting on how expensive

Santa Fe is, I knew I had to save the day. My only recourse was to get a job!

After all, said I to myself, with a shudder, "Mickey and Larry rescued me. And they are so good to me," I thought, misting up a bit myself.

Now, lest you think I was turning into a big crybaby with a soft underbelly of mush, I must confess here and now that my plan wasn't totally unselfish. I am the poster cat of altruism, as is well known throughout the land, but my gestures were not strictly humanitarian. There was some thought in this newly formulated plan for yours truly. I did, after all, need to help my pets support me in the manner to which I've become accustomed. There was my weekly allowance for cat furniture, exotic toys, and my visits to the Cat Spa to consider.

I gave Mickey a farewell lick and told her not to worry anymore because I had an idea in the works. I gathered my purse and scampered off to El Caton, my favorite milk bar. I had a steamed milk and thought about my options. Steamed milk always helps me think.

I took my notebook and scratched out some ideas for possible jobs. I have been told for some time by all my political friends that I would make one terrific mayor — it's only true.

But it occurred to me that this job wasn't up for grabs for another four years, which made the time frame awkward. Recalling Mickey's forlorn expression made me realize I couldn't possibly wait that long.

I knew that I could sell my novel or, better yet, my memoirs, or even this very diary. But Mickey might feel bad if I got published before she did. And hadn't she just told me how abysmal the pay for writing is?

I needed to do some quick research, so I hied myself over to the library to the desk of Valerie, my favorite reference librarian. "I need to make money and lots of it in a hurry," I explained.

Without missing a beat, the fair librarian led me to a sunny corner of the Santa Fe Public Library to a section called CONSULTANTS. She pulled out a book called *What Is a Consultant and How You Can Be One*. I looked up the definition of a consultant and it immediately appealed to me. "Part-time work, full-time pay, specialized knowledge and a lot of bravado." Sounds like someone had me in mind when they wrote this description.

The second book I happened upon was entitled *The Most Money in the Least Time: Consulting Made Easy*. It listed the most lucrative consulting positions:

1. Politicians
2. Former criminals or shady characters
3. Scientists

I had eliminated politicians as a possibility because the process took too long; witness the mayor's spot. Of course, you already know of my sterling character and virtue, so becoming a shady character was clearly out of the question. Therefore, I logically moved on to science.

Having made my consulting choice, there wasn't a moment to lose. I needed to go visit my friend, Chaos, the eminent feline scientist, to see how I should go about getting a consulting job at the nearby Los Alamos National Lab. I ran as fast as my sturdy little legs would carry me and soon arrived at the Santa Fe Institute where Chaos was enjoying a little sabbatical from said Lab.

Chaos, an elegant, highly intelligent grey Persian with yellow eyes, was ensconced in his office, which turned out to be a warm, cozy solarium. He was stretched out, enjoying a

sunbath with his nose and whiskers immersed in a scientific tome.

"What Ho, fair feline," I chirped.

"Vanity," he answered without even looking up, recognizing my usual salutation. "How good of you to stop by. I was, per chance, thinking of you. I have been developing a new theorem and wanted to get some input from you." With his starboard paw, he pointed to the blackboard behind him on which was written a series of equations. We batted his theory around for a bit, checked it against the data, and concluded that the analysis was rigorous. Ah, but it felt good to stretch the little grey cells. This stimulating exercise over with, I felt I had better get down to business.

"Chaos, old pal, old chum," I said, while relaxing in my own little square of sunshine. "It seems that hard times have hit my household — Mickey has lost her job. No more free-lancing for me. I need to get a job and help my pet humans pay their bills."

Chaos adjusted his monocle and buttoned his cardigan sweater. I could tell he was thinking because he always reverts to his country of birth, complete with British accent, when his considerable brain is engaged. "Vanity, old sock, with your

imposing scientific background, you would be a splendid consultant at the little lab on the hill."

As I had hoped, he happened upon this conclusion on his own. People tend to embrace an idea when they think it is their own darling brain child.

"Here's how the old consultant game works. I'll give you a rawther remarkable build up and suggest to the powers that be that you present a seminar. With your way with words and facile brain, they'll hire you on the spot."

"There's a bit of urgency in my plight. Mickey's bills are already overdue. I wonder how quickly you can expedite the matter."

"Not to worry. I'll call my good friend MC^2 to see if he can squeeze you in next week." He quickly made the call and exclaimed, "Spot of good luck, Vanity, old girl. There was just a cancellation for this coming Friday afternoon, so I booked you. "

Chaos and I discussed some ideas for my talk. I couldn't wait to strut my stuff.

Friday arrived practically before I knew it. Chaos drove me up the hill to L.A. for moral support. MC^2 greeted us in the auditorium. The next thing I knew I was on stage.

As you know by now, I am by nature a very unassuming soul. However, I must alter my character slightly to brag because, to put it mildly, I was brilliant. I wowed them with my latest invention, CAT SCANS. For my demo, I had arranged for ten friends of mine, all of different breeds, to attend the lecture. On cue, the cats waltzed by while I scanned them with this device, which printed out the name of their breed. For instance, when my friend Alexandra strolled by, my machine declared her to be ABYSSINIAN. Next was Max who strutted and fretted his stuff while the machine told the audience he was a MANX.

The audience seemed amazed, since no one was familiar with my latest invention. They all seemed acquainted with CALLER I.D., a similar machine that I had worked on.

I worked in a little family history and pointed out to those scientists working in weapons that my ancestors had invented the CATAPULT, one of the earliest military weapons. It has been used since time immemorial, I noted proudly, to toss objects like rocks or cows from point A to point B.

Then I brought up the legendary CATENARY, a classic problem posed and solved by one of my forbearers. "It's true," I said in that cute little way that I have, "that CATENARY is just a fancy Latin word for chain." While the audience was chortling I

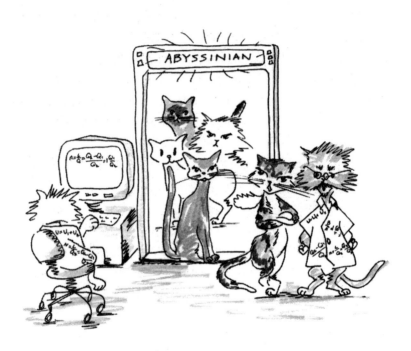

added that the important scientific properties of Catenary formed the basis for designing suspension bridges.

I brought up my theories on the modeling of climate with a discussion of the prediction of CATACLYSMIC meteorological events. Then I waxed eloquent on gas discharge and the damaging effects of CATIONS. Trying to appeal to a mass audience, I threw around the pros and cons of CONCATINATION with the computer folks. I ended this section with a brief discussion on the causes of CATAPLEXY.

I concluded my presentation with my interpretation of The Second Law of Thermodynamics, which, freely stated, says that "Nature likes things just the way they are." I described nature as a bunch of molecules that have arranged themselves so that they are most comfortable in their given situation. I pointed out to my fellow felines in the assembly that we cats by definition are practitioners of the Second Law; humans, canines, and other uninformed mammalia, on the other hand, choose to fight against the Second Law, much to their long-term disadvantage.

As a catlike example of The Second Law, I pointed out that while cats snooze in the sunlight, humans always seem to

be frantically building or moving things. Most of these misguided efforts are irreversible, in the sense that it is impossible to tear down a structure and restore the property to its previous state. I stopped for a moment and handed out bumper stickers that said NATURE BATS LAST. This saying, which I coined, by the way, nicely illustrated my point.

I continued for my grand finale, "Given enough time, the buildings will decay and fall down and, eventually, all evidence of this structure will vanish. This is nature's way of saying that things were all right in the beginning. Uncatlike behavior can only be construed as a waste of time."

The response exceed my fondest hopes. There was thundering applause while the many cats in the overflow auditorium formed a pyramid and placed me on the very top perch. Suffice it to to say I was a hit! Chaos told me I had been splendid and that I was a shoe-in for the job.

Vanity Goes to Fiesta

It is a frabjous day in the City Different and my heart and soul are filled with felicity, frolicking and foolishness. First of all, dear Reader, I got the job. I'm sure you never doubted it, but I am now a well-paid consultant to Los Alamos National Laboratory. Not only that but, out of the blue, I got a phone call from my good friend Cato, a tutor at St. John's College, here in Santa Fe. Via the grapevine, Cato had heard that I was looking for a job and offered me another part-time position. I am now the Adjunct Professor of Mousing at St. John's. It's a real deal—my office is in the library where I am in charge of mouse patrol. Not only am I chief mouser, I will also be conducting a tutorial on "Mice and Their Contribution to Literature." I will be giving seminars on *Of Mice and Men*, *The Mousetrap*, and *Stuart Little*.

My household is once again filled with contentment, happiness, and, best of all, money. Besides all this bliss, Santa Fe was now experiencing fall, my favorite time of the year. If this

weren't enough, it was also Fiesta, the most wonderful of all the Santa Fe celebrations.

Fiesta, for those of you from out of town, is a Spanish festival celebrating the "bloodless recapture of Santa Fe from the Pueblo Indians." It has some lovely religious ceremonies, but a lot of it is purely for fun. It's Santa Fe's answer to Mardi Gras. There are a multitude of festive events, but the one that is nearest and dearest to my heart, the one I wouldn't miss for a truckload of mice and birds, is the Human Parade. I suppose the fact that this year I am the Grand Marshall makes me like this event even more.

Let me give you a little background on this parade. Every year at ten o'clock on a given September Saturday morning, all the pets in-the-know dress their humans in the most fetching attire, put them on leashes, and parade them around Paseo de Peralta. Now although this is great sport, our own little version of The Easter Parade is not strictly for fun. There is a good deal of competition involved as well. There are prizes awarded, Win, Place, and Show, and nothing pleases our humans more than wearing a prize-winning blue ribbon around their neck. It means so much to the darlings.

This year my friend, Guadalupe Gutierrez, is the fiesta queen. She had invited me to sit on the special podium on the plaza to help judge the parade. The day of the parade was a glorious late summer/early fall day, the type you only get in Santa Fe. The sky was a brilliant turquoise blue, the sun was shining brightly, and the smell of green chiles roasting filled the air. If I do say so myself and, of course, I do, Guadalupe and I both looked especially stunning .

Guadalupe is a lovely, petite pure black cat with exquis- ite green eyes. She was dressed in a traditional Fiesta costume consisting of a white lace blouse, a white pleated Fiesta skirt, accentuated with a concho belt. She wore a squash blossom necklace, and to top off the outfit she wore a charming white Spanish mantilla on her head. The one red rose discreetly tucked into the white veil completed the ensemble perfectly.

As for me, I am usually the soul of modesty. Today, however, I know I looked especially beautiful and I just can't help boasting about it. La Socidad Folklorica helped me select my outfit and generously offered me lovely old costumes from their collection of fiesta wear dating back to the 1860s. Together the grande dames of La Socidad and I choose an elegant gown that placed me at the height of my sartorial splendor. Let me

tell you about it. I wore an off-the-shoulders midnight-black lace tea-length gown that perfectly complemented my natural black, brown, and white coloring. Around my neck was a delicate onyx necklace and on my ears hung matching dangling earrings. The antique black and silver fan I carried was the crowning accoutrement to my glorious Fiesta garb.

But enough about yours truly. I need to tell you about the incredible Human Parade, the most endearing event in the whole Fiesta. There are several different competitions. Because we on the Fiesta Committee had noticed, after careful observation, that humans come in all shapes and sizes, we created a special category to celebrate this fact. Inspired by the nearby Albuquerque International Balloon Fiesta, we devised a SPECIAL HUMAN SHAPES CATEGORY.

The Santa Fe animals, on my advice, had done an absolutely splendid job of adorning their housekeepers in shapes that represented the best of Santa Fe and the Southwest. For example, my friend Ramon the Rabbit got in the swing of things by dressing his pet human, a tall skinny drink of water, as a chile pepper. Then on the other side of the scale, so to speak, my amigo, Pancho the Porcupine, had his very spherical, roly-poly human housemate decked out as a balloon.

There was an entire streetful of imaginative entries — pumpkins, cacti, sopaipillas, a tent rock, an O'Keeffe flower, and a mountain. The best of show was the entire family huddled together with a bright red and green blanket over them representing The Whole Enchilada.

Following this cornucopia of shapes was my favorite part of the parade, the Hysterical/Historical Category. In this event, we of the animal kingdom poke fun at our good-natured human friends and other silly types that inhabit Santa Fe. I had entered my pet humans in this event. They are such good sports and I was pleased with how much in character they were with the parts I had chosen for them. I had gussied Mickey and Larry up to look like TURISTAS. Both were covered from head to toe in Indian jewelry. Larry had on a ten-gallon hat and a bolo tie with a turquoise stone the size of Texas. Mickey had five cameras around her neck while Larry carried two video cameras. He took pictures of everything, including a group of Japanese tourists. Even though there was a large "No Smoking" sign posted prominently on the parade route, Larry was puffing away on a stogie and handing out cigars to other aficionados in the crowd. He had three bulging money clips attached to his belt. An entourage of vendors followed him; from them he bought

jewelry, pottery, ristras, and a state-of-the-art Low Rider decorated with a Kachina and chile motif.

Next in the pecking order was a potbelly pig whose human was dressed in a costume that was a real crowd pleaser—A DEVELOPER. The character looked like Snidely Whiplash, the villain of this year's melodrama. He was wearing a black mustache that looked curiously like the overdone white "milk mustache" and was carrying a sign that read, "Got land?" On his back was another sign that said, "Will build to suit me." The pig, getting into the swing of things, sported a plaque that announced, "Brick and mortar 10, Trees and land 0." I don't know if it was the black cape and whip that Snidely wore or the sentiments he was espousing, but the crowd took great pleasure in hissing and booing him.

Who would have thought my buddy Apache, the town's most good-natured cat, would have outfitted her humans to look like CALIFORNIANS? Apache, a sweet, slightly plump Russian blue, known to her friends as Girl Grey, had her humans on leashes. At one point, the couple became all tangled up in said leashes, but Apache righted the situation quickly by dashing this way and that to get the leashes to their proper positions. Once she did, we could see the couple, who looked

like they should be gracing the front of a Beach Boys Album. The woman was blonde, as perky as a cheerleader on steroids, and so svelte she looked like all she ever ate was a stick of celery and a bottle of Perrier. The man could have doubled for a Ken doll with his blond hair, tan face, and trim body.

Both CA transplants displayed huge wads of money that they used to play a game of SANTA FE MONOPOLY. As they walked along, they simultaneously bought houses and property, all the while loudly exclaiming, "Boy are these cheap. Are you sure this price is right?"

The parade stretched on and on, and I must say, my heart swelled with pride at the creative ways in which my animal friends had bedecked their humans. Before announcing the awarding of the prizes, let me tell you about a few more of my favorites. There was a Gaggle of Homosapiens dressed as Artists, each one portraying a different subspecies. One artist, looking like Rudolfo from *La Boheme*, held a sign that read THE PORTRAIT OF AN ARTIST AS A YOUNG BILLBOARD. Waving his paintbrush at the crowd, he stopped and gave a passionate speech. "Artists, remember that you are Bohemians, so look the part. Any tourist worth his salt is not going to pay good money

to an artist in a gray flannel suit. Being an artist in Santa Fe is very competitive, so it certainly doesn't hurt to advertise!"

Next in this ensemble cast were two terrestrials carrying a sign that said YOU ARE WHAT YOU PAINT. One stopped and addressed the crowd, "Artists, your clothing should be indistinguishable from your canvases. If you're a colorist, your fans can't possibly take you seriously if you dress in basic black. Make your every outfit a virtual rainbow." This man was definitely a method actor because his jeans and shirt were artfully paint-splattered. His colleague was obviously a potter who followed this advice. He was so clay-covered that he looked exactly like a clay pot. He looked so authentic, as a matter of fact, that one of the cats in the audience jumped on him, hoping to take a dirt bath.

Finally, there was a float from Roswell, New Mexico, featuring "The Alien Nation" for which our southern neighbor is so well known. There was a space ship looking a good deal like the Enterprise, with a cast of characters on the float appearing to be on their way to the intergalactic bar in a *Star Wars* movie. One alien who resembled Jay Leno was doing his shtick. "Hey, humanoid parade goers," he shouted at the audience, "how can you tell the difference between an Alien and a Santa Fean?" He

paused to throw some candy to the kids in the crowd. "Give up?" he continued, "Well, I'll tell you then. Aliens dress better and are always on time."

There was something about this parade that made me realize how much I loved Santa Fe. Before I knew it, I was purring and kneading right there on the grand stand. This would never do, so I decided to let all this happiness overflow go into my closing speech. I did mention, didn't I that I am the Toastmaster for the City Different Feline Chapter of Milktoastmasters?

"Friends, nomads, and countrymen, lend me your ears. I want to end this parade with a toast to our fair city. In this parade, we've poked fun at our town's foibles. But how about its virtues? The weather is purrfect — it's nice and dry with hardly any rain to wet our fur. The fleas and ticks are practically nonexistent, especially if you talk to some of our brethren in the East. Even though we all think the town is getting too big, it's still nice and small most of the time. Why it only takes me five minutes to get to the vet whereas my cousin Sadie, the Siamese, says it takes her an hour to get to her vet in Washington, D.C.

"And Santa Fe humans love their animals," I exclaimed loudly, casting a fond glance at Mickey and Larry.

"And we love them," piped in Guadalupe, thinking of her kind owner, Elaine.

"Viva Fiesta," I shouted. "Viva Santa Fe," screamed the crowd.

"God bless us everyone," yelled out a basset hound. She was obviously in the wrong story, but the sentiment fit the festive mood of the crowd very nicely.

Peggy van Hulsteyn's three purrsnickety cats told her quite frankly that they were tired of having their pet human writing *The Birder's Guide to Bed and Breakfasts* but refusing to bring home any live birds for them to play with. Optimism rose among the feline literati when the author wrote *Sleeping with Literary Lions: The Booklover's Guide to Bed and Breakfasts* that they were certain would feature them. But much to their dismay, they discovered that book was about human authors and writing it meant that van Hulsteyn would be traveling around the country rather than staying at home to tend to their needs. In desperation, Vanity the resourceful Calico, took matters into her own competent paws and handed over her letter-perfect diary and said, "It is time for a feline byline. This will amewse your readers."

Jacquelyn Rudolph Quintana was born and raised in Northern New Mexico and discovered her passion for the arts at an early age. She studied fine art at New Mexico Highlands University and commercial art at Central Texas College. Although Vanity claims to be the source of inspiration for these illustrations, Quintana mentions that her background as a sculptor and her study of architecture truly do play an important role.